THE WORLD OF
WILLIAM JOYCE
SCRAPBOOK

Winnona Park
Elementary School

THE WORLD OF
WILLIAM

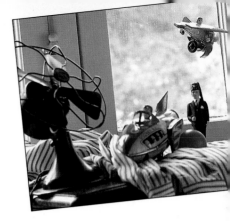

JOYCE
SCRAPBOOK

TEXT AND ART BY WILLIAM JOYCE

PHOTOGRAPHS BY PHILIP GOULD

DESIGNED BY CHRISTINE KETTNER

A LAURA GERINGER BOOK
An Imprint of HarperCollinsPublishers

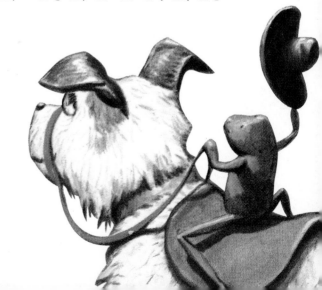

For Philip, Chris, and Laura—W.J.

FOREWORD

When I go to schools, I get asked a lot of questions. How do you do a book? Where do you get your ideas? How did you learn to draw? How long does it take to do a book? Do you put your family in your books? Do you get to sleep late? What was the first book you ever wrote? Most people don't know any author/illustrators, and you can't find them listed in the phone book like doctors or plumbers or landscape architects. Every author has his own way of doing a book. For the next few dozen pages, I'll try to answer the questions about how I do mine.

Contents

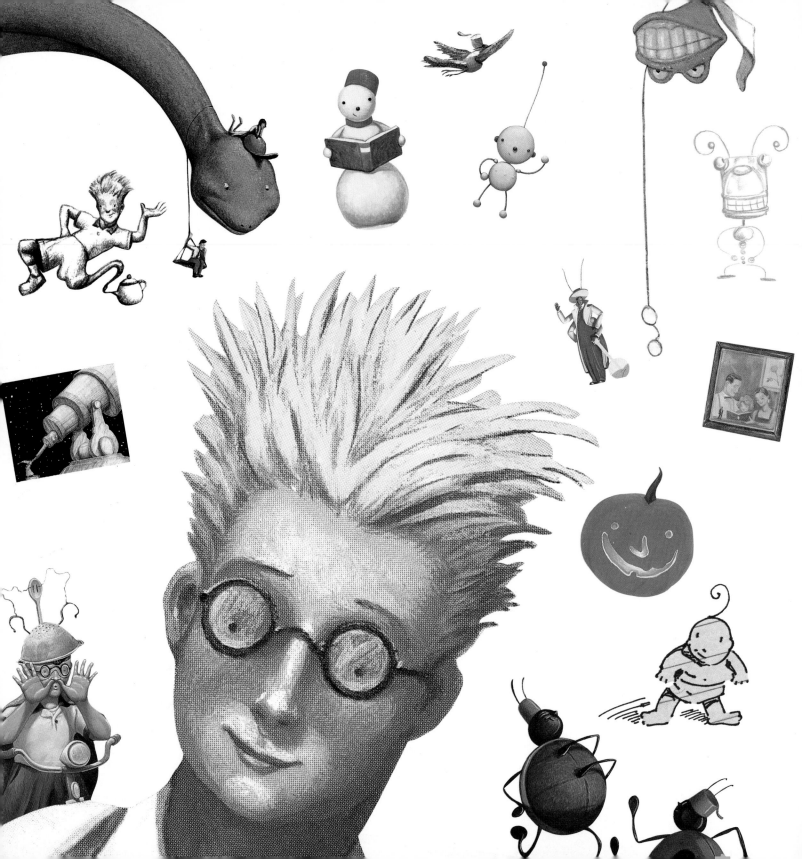

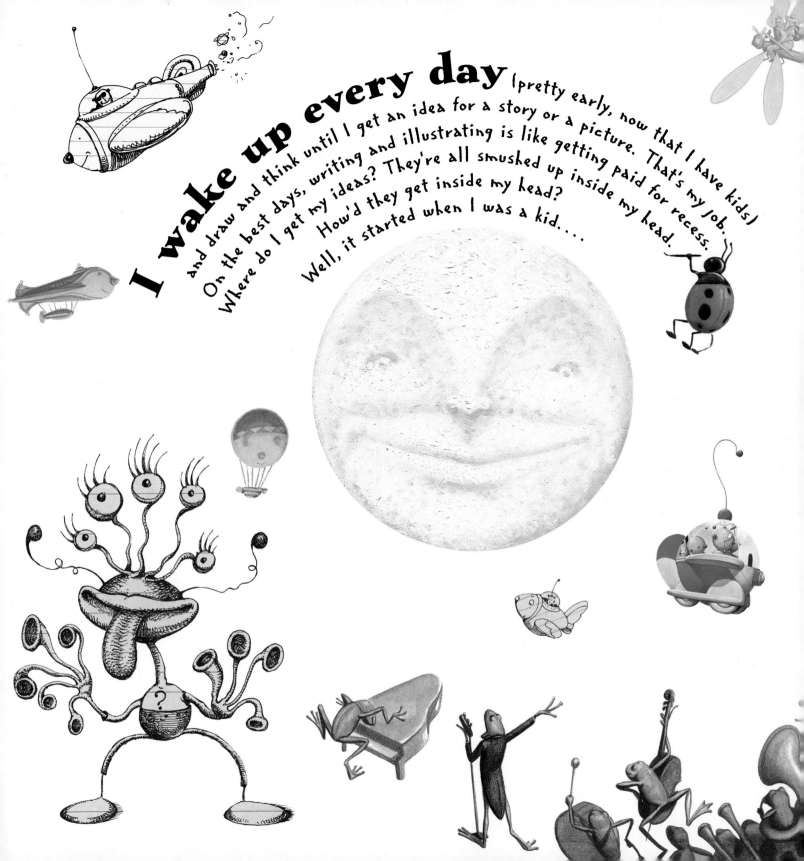

I wake up every day

(pretty early, now that I have kids) and draw and think until I get an idea for a story or a picture. That's my job. On the best days, writing and illustrating is like getting paid for recess. Where do I get my ideas? They're all smushed up inside my head. How'd they get inside my head? Well, it started when I was a kid. . . .

When I was a kid,

I didn't have many books, just a Mother Goose book, a fairy-tale book, and a book called *Where the Wild Things Are.*

But I did play with my toys and watched TV a lot. TV was different then. There were only three channels and all the shows were in black and white, but there was plenty of cool stuff to watch. On summer nights, my sisters and I would watch cartoons, westerns, and monster movies all night long (or until we fell asleep).

I loved the stories in those old movies and I loved the drawings in *Where the Wild Things Are.* They really got my imagination going. So I started making up my own stories and drawing pictures to go with them. At first they were just about monsters and cars and spaceships and dinosaurs eating my sisters.

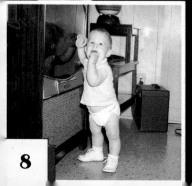
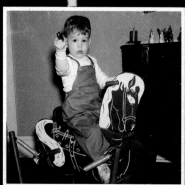
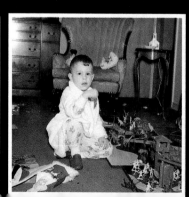

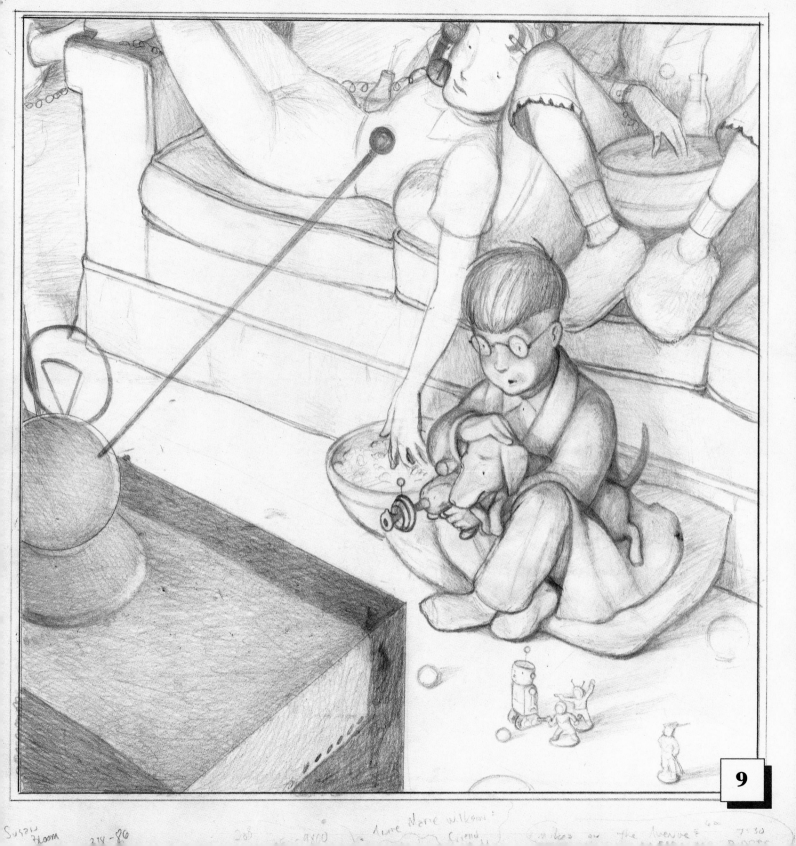

My first drawings

were pretty simple. But I kept drawing and painting and telling stories with my pictures. My parents let me have art lessons, and I had a couple of teachers and librarians who encouraged me. I read lots of books and tried all different mediums—watercolors, oils, pencils, pastels, charcoal, crayons, felt-tipped pens, pen and ink—you name it. The older I got the more I learned. I had favorite artists that I studied and even copied. I didn't copy them to make it easier to draw a picture. I copied them to learn how they drew. My favorite artists were Maurice Sendak, who did WHERE THE WILD THINGS ARE, Beatrix Potter, who did PETER RABBIT, and N.C. Wyeth, who did lots of famous stories like ROBIN HOOD and TREASURE ISLAND. There were times when my drawings looked too much like theirs, but in time I found my own style.

AGE 7

AGE 5

AGE 8

AGE 9

AGE 11

AGE 8

10

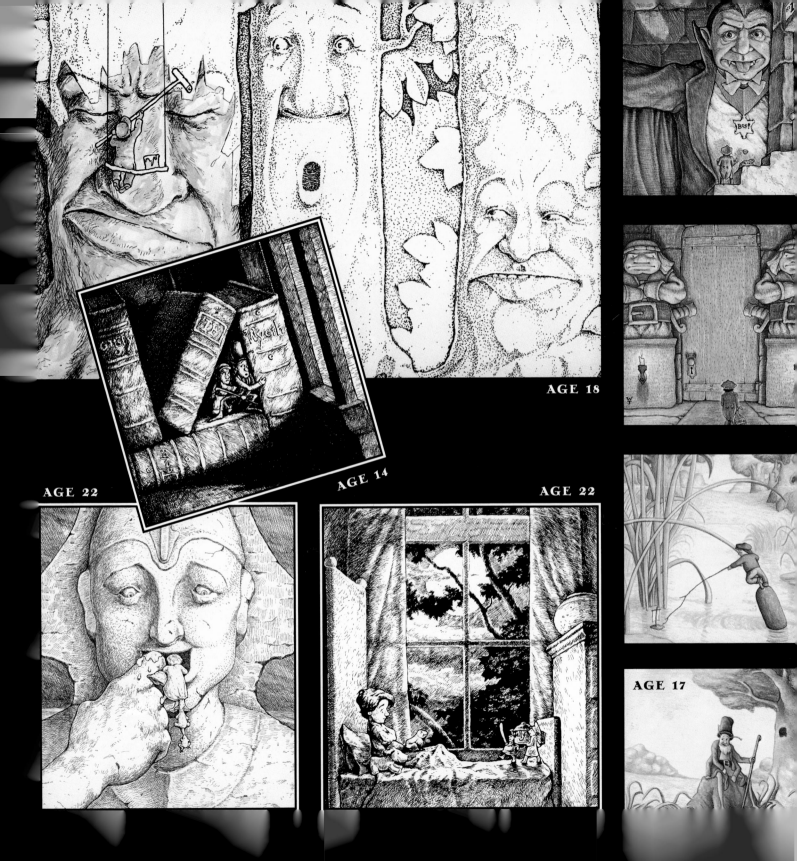

AGE 18

AGE 22

AGE 14

AGE 22

AGE 17

BOOK BEGINNINGS

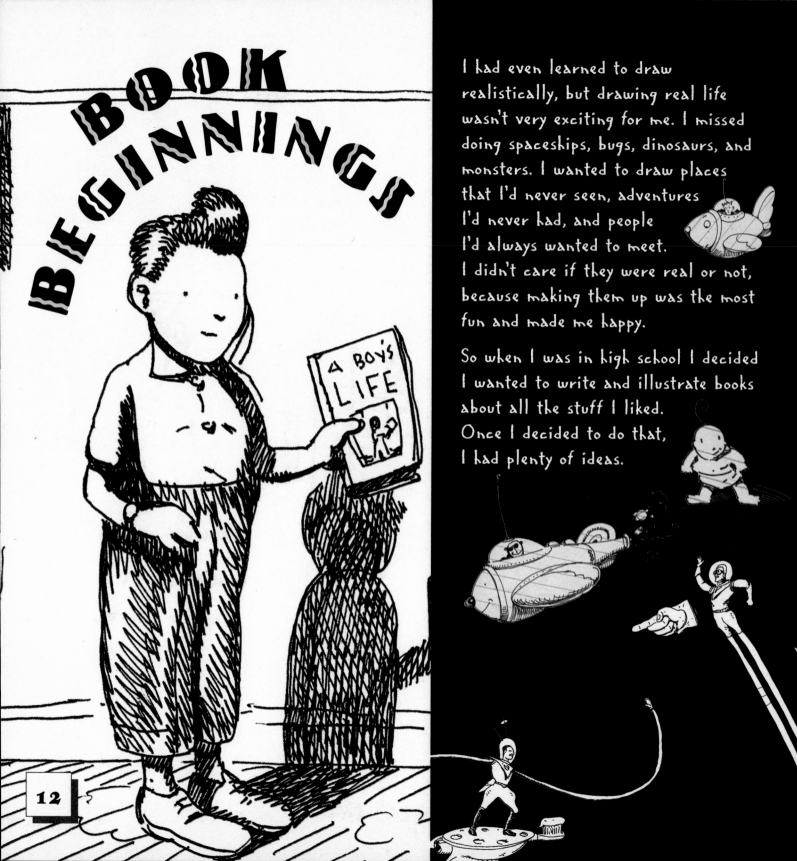

I had even learned to draw realistically, but drawing real life wasn't very exciting for me. I missed doing spaceships, bugs, dinosaurs, and monsters. I wanted to draw places that I'd never seen, adventures I'd never had, and people I'd always wanted to meet. I didn't care if they were real or not, because making them up was the most fun and made me happy.

So when I was in high school I decided I wanted to write and illustrate books about all the stuff I liked. Once I decided to do that, I had plenty of ideas.

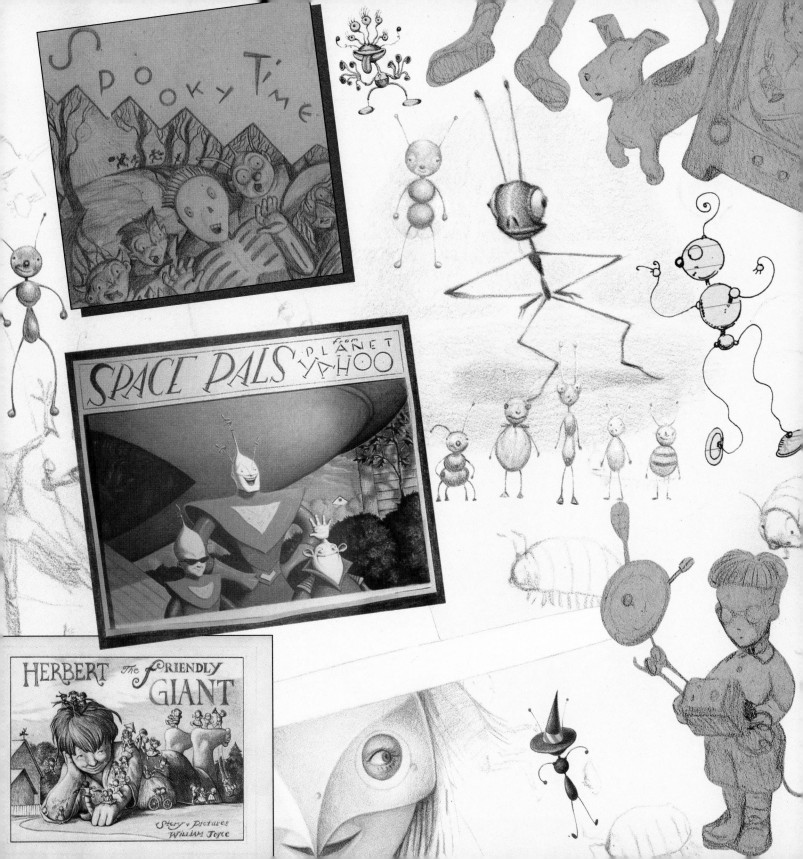

SPOOKYTIME

SPACE PALS from PLANET YAHOO

HERBERT the FRIENDLY GIANT

Story & Pictures
WILLIAM JOYCE

How I Do a Book

It takes a long time to do a book, so I have to like the story the idea a whole lot. The shortest time I spent on a book was two months. That was on my first book, *Tammy and the Giga. Fish*. But I spent almost two years on my book *Santa Calls*.

First I plan the whole book with a series of pencil drawings. figure out what the people and places will look like and wher the words will fit. These first drawings are often very loose, they help me figure out how to do my paintings. The color paintings take the most time to do, so the more I plan, the le likely I am to make a mistake. If you look closely and compar the sketches and paintings, you can see that I change my mind a lot. I move people around and make their hair or clothes different.

"Let's put it in the pickup truck," said Father.
"Okay," said Grandfather.
Tammy cried, "No!"

Shoes for fishing, shoes for wishing,

rubber shoes for muddy squishing.

SHOES FOR FISHING
SHOES FOR WISHING...

RUBBER SHOES FOR MUDDY
SQUISHING....

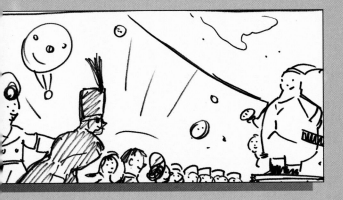

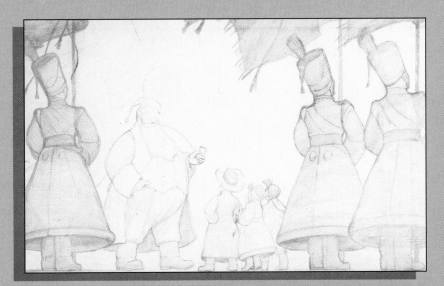

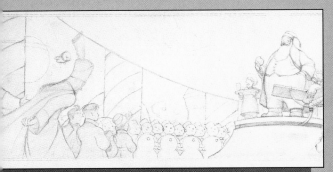

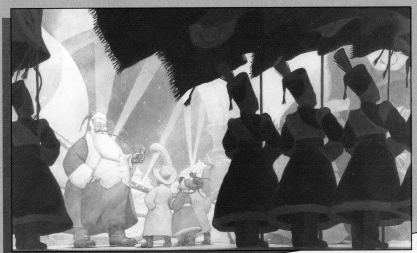

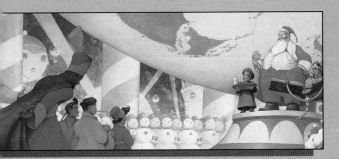

Sometimes I'm unhappy with a finished painting and start over from scratch, like with these pictures from *Santa Calls.*

I usually paint using very watery layers. First I do yellow, then red, then blue, and then brown or black. Using these four colors, I can mix any color there is.

Yellow Red blue black

15

GEORGE SHRINKS

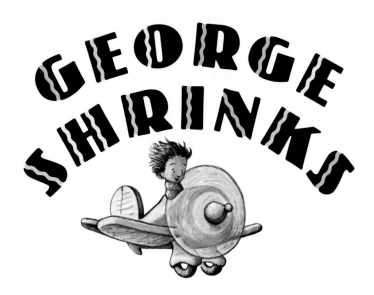

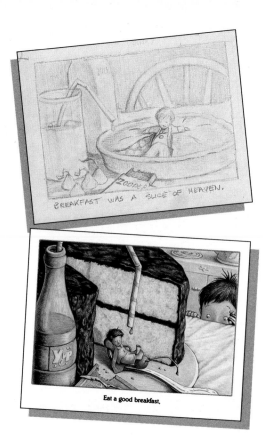

BREAKFAST WAS A SLICE OF HEAVEN.

Eat a good breakfast.

AND FINALLY THROUGH AN OPEN DOWNSTAIRS WINDOW...

The first book that I both wrote and drew the pictures for was *George Shrinks*. Ever since I was a little kid I loved stories about people who were the wrong size. King Kong was way too big for everything, and Stuart Little was way too small. One day I found some of my old toys in a box. Mixed up with all the dinosaurs and army men was a little airplane that had a tiny pilot, and that got me thinking.

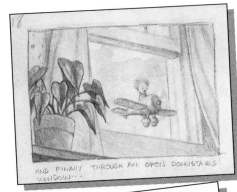

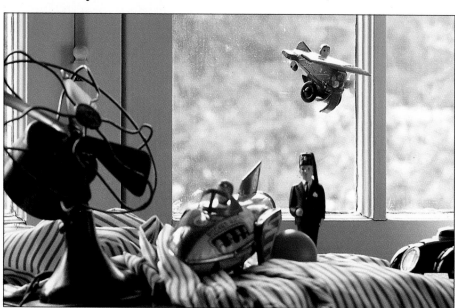

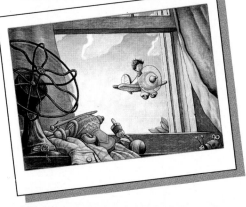

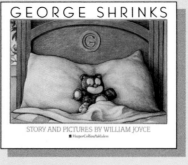

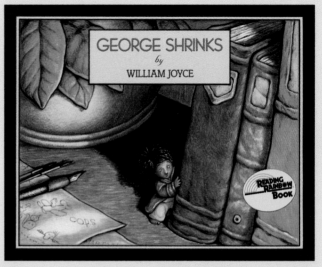

What if a boy named George (George is my Dad's middle name) shrank one day while his parents were away? What would he do? Would it be fun? Would it be scary? What would he eat?

So that's what I made *George Shrinks* about—how fun and scary and neat it would be if, just for a day, you were the same size as your toys. And of course I had George fly in that toy airplane.

But I don't make *everything* up. I used some real toys in the book like my old teddy bear—he's on the title page. I even used some of my real books and other stuff like my desk and a table fan and a potted plant.

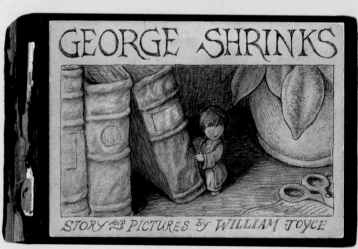

GEORGE IS SHRINKING . . .

How many teeny tiny Georges can you find, starting on the next page? Find the answer on page 48. . . .

SHRINKING. . .

SHRINKING. . .

SHRINKING. . .

SHRINKING. . .

SHRINKING. . .

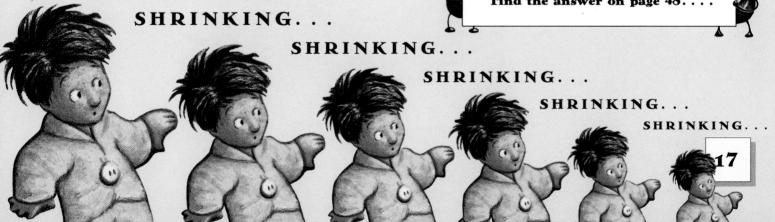

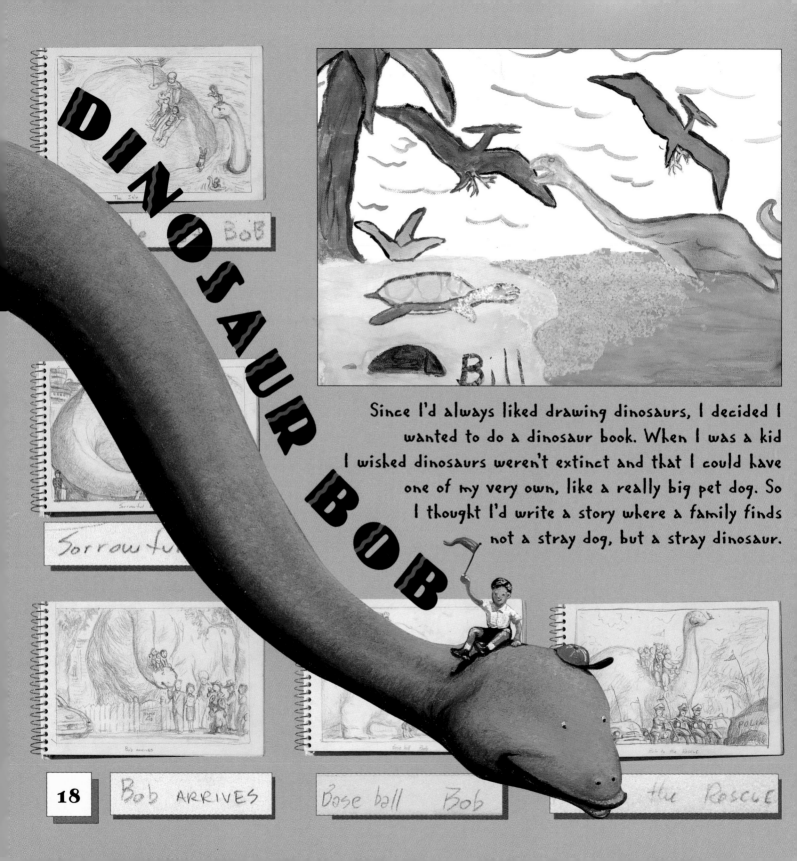

DINOSAUR BOB

Since I'd always liked drawing dinosaurs, I decided I wanted to do a dinosaur book. When I was a kid I wished dinosaurs weren't extinct and that I could have one of my very own, like a really big pet dog. So I thought I'd write a story where a family finds not a stray dog, but a stray dinosaur.

Bob ARRIVES

Base ball Bob

the Rescue

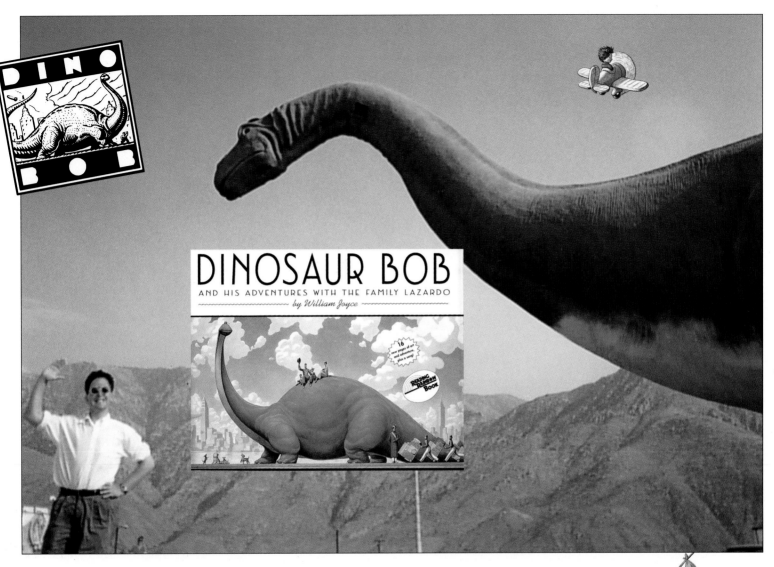

DINOSAUR BOB
AND HIS ADVENTURES WITH THE FAMILY LAZARDO
by William Joyce

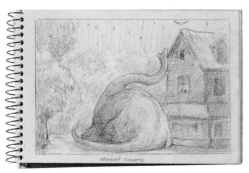

stardust crooner

I thought about King Kong and the American tall tales like "Paul Bunyan," which was the story of a giant, and "Mighty Casey at the Bat," which was about a baseball player. I sort of combined them all and came up with a dinosaur named Bob who could play baseball and the trumpet and dance the Hokey Pokey.

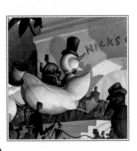

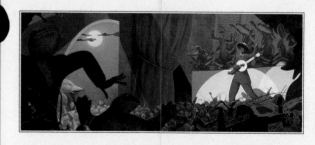

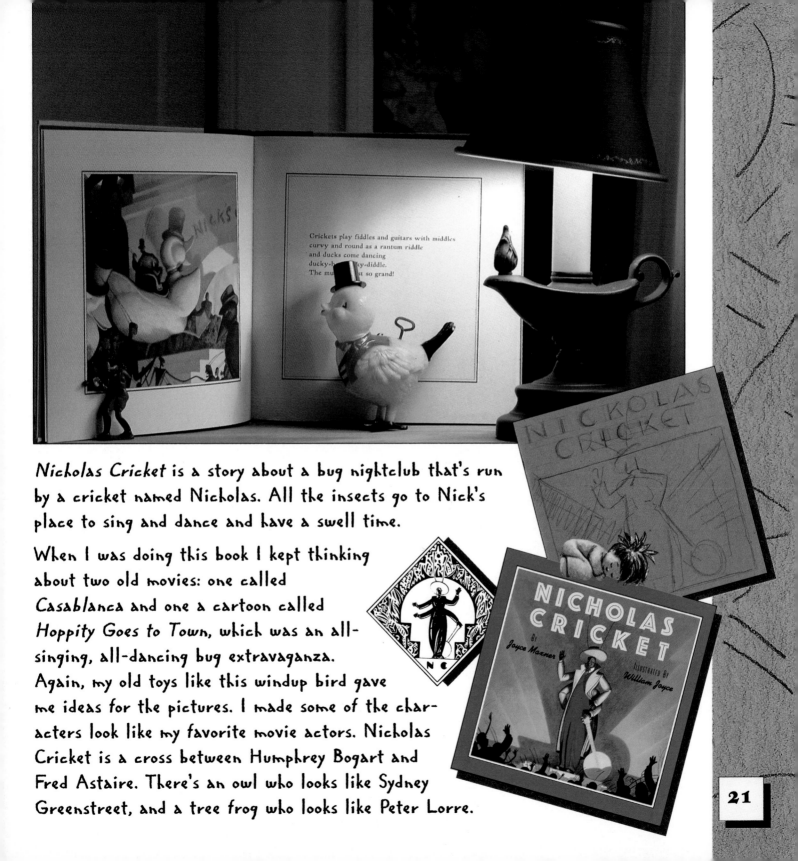

Nicholas Cricket is a story about a bug nightclub that's run by a cricket named Nicholas. All the insects go to Nick's place to sing and dance and have a swell time.

When I was doing this book I kept thinking about two old movies: one called *Casablanca* and one a cartoon called *Hoppity Goes to Town*, which was an all-singing, all-dancing bug extravaganza. Again, my old toys like this windup bird gave me ideas for the pictures. I made some of the characters look like my favorite movie actors. Nicholas Cricket is a cross between Humphrey Bogart and Fred Astaire. There's an owl who looks like Sydney Greenstreet, and a tree frog who looks like Peter Lorre.

Crickets play fiddles and guitars with middles curvy and round as a rantum riddle and ducks come dancing ducky-h... ky-diddle. The mu... ... st so grand!

NICHOLAS CRICKET

NICHOLAS CRICKET
BY
Joyce Maxner
ILLUSTRATED BY
William Joyce

A Day with WILBUR ROBINSON

A Day with
WILBUR
ROBINSON
WILLIAM JOYCE

GROW STRONG and HEALTHY
Enjoy Delicious
ICE CREAM
IN
TARZAN
CUPS . 5¢
SAVE THE LIDS
for VALUABLE New! FREE PRIZES

A DAY
with the
ROBINSONS
WILLIAM JOYCE

one of the frogs jumped
up onto my hand and did
a Tarzan yodel. He was
wearing Grandfather
Robinson's teeth.
 "I found them! I
found them!" I cried.
 Everybody shouted,
"Hooray!" except for
Wilbur, who did a Tarzan
yodel too.

Mrs. Robinson
Apes" aloud.
mped up onto
tarzan yodel. He
ther Robinson's

teeth.
 "I found them! I found them!"
I cried.
 Everybody shouted "Hooray!"
except for Wilbur who did a Tarzan
yodel too.

A Day with Wilbur Robinson is about a lot of things that actually happened to me when I was a kid.

My dad was always finding really cool stuff with his metal detector; my uncle told me he was from outer space; my grandfather had false teeth that were always getting lost; my sister paid me to feed her grapes while she talked to her boyfriend on the phone; and our dog was blind (I gave her glasses in the book).

The kid down the street from me lived in a big grand house. His family had a purple swimming pool and purple cars, their kitchen was purple, their furniture was purple, and their two poodles were dyed purple. His house was *really* fun to visit.

So I mixed all these things up with some of my favorite movies like *Tarzan* and *The Swiss Family Robinson* and *Bringing Up Baby* and *Earth* vs. *The Flying Saucers*, and what I ended up with was a book about a normal kid who spends the night at this amazing house filled with robots and animals and really interesting people.

Anytime you spend the night at a friend's house, anything that their family does that's different from what your family does seems really strange. In *A Day with Wilbur Robinson* I just exaggerate that feeling a lot.

One of the things I wanted to do when I was a kid was to be able to fly, so I gave one of the Robinsons his own antigravity device.

LIZ

LIZ

LIZ

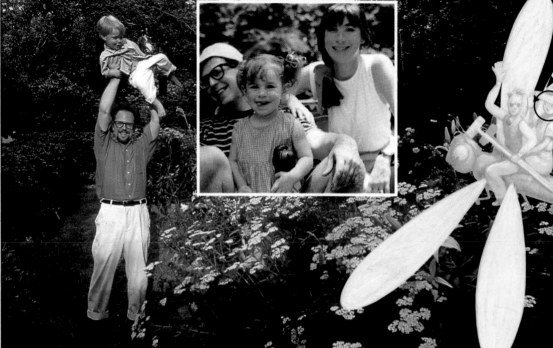

LIZ

The Family

I have two kids, a boy and a girl. Jack is a large, mud-dwelling child—he especially likes to take off all his clothes and wallow in the dirt. He also spends a lot of time running around the house with his Mars Attacks ray gun, chasing imaginary wild things. My daughter, Mary Katherine, used to be called The Wonder Baby until she became too big. She likes to hunt for fairies with her flashlight. I get lots of story ideas from these little guys.

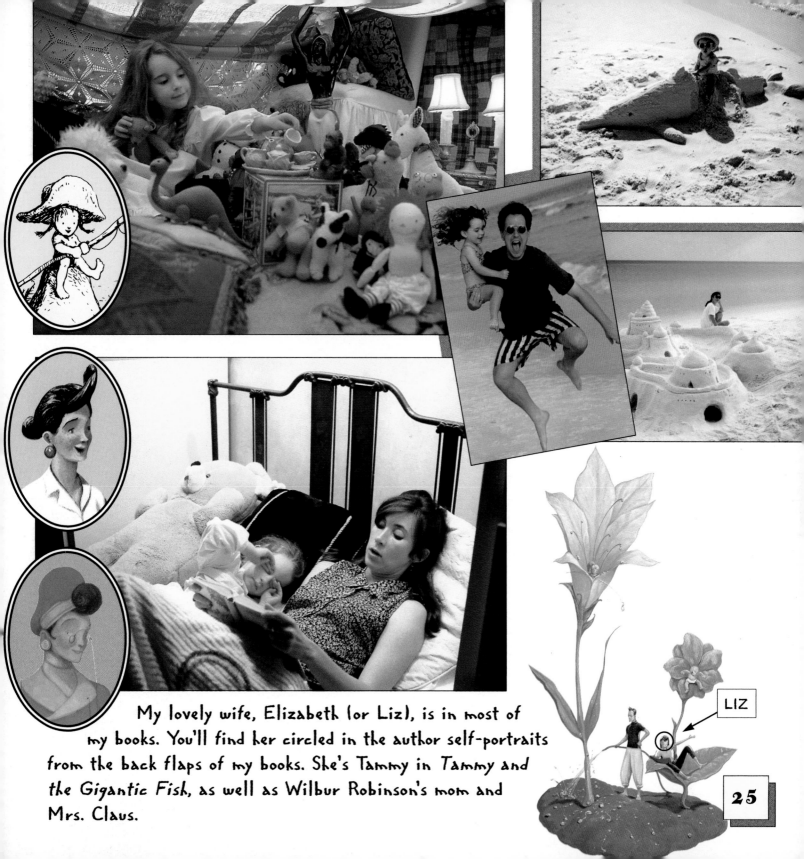

My lovely wife, Elizabeth (or Liz), is in most of my books. You'll find her circled in the author self-portraits from the back flaps of my books. She's Tammy in *Tammy and the Gigantic Fish*, as well as Wilbur Robinson's mom and Mrs. Claus.

LIZ

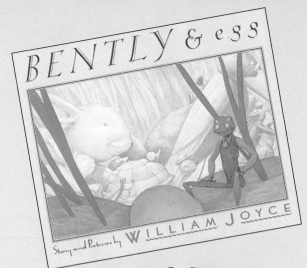

BENTLY & EGG

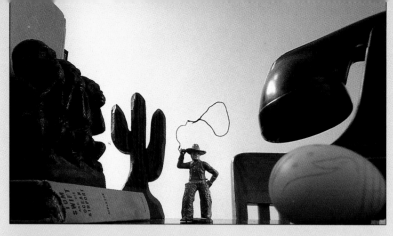

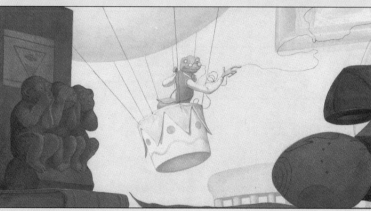

I set up my cowboy with lasso with the telephone and bookends in my studio to use as a model for the painting above.

I've always liked the story of Humpty-Dumpty, so I do lots of egg paintings. I even paint eggs at Easter, but I'd never done a story with an egg in it.

One day when my wife was about to have our first baby, I was looking at how incredibly big and round her stomach had become. It looked sort of like a giant egg. I was also kind of nervous about being a dad, so I worried about what would happen when this giant belly egg hatched. Then out of nowhere I thought of this story about a tree frog named Bently who likes to paint. His best friend is a duck who lays this egg.

Bently is jealous of the egg, but after he paints it he feels differently.

He gets really attached to the egg, and once it hatches he really likes it.

My wife finally did hatch. I didn't ever paint our daughter Mary Katherine, but I'm pretty attached to her.

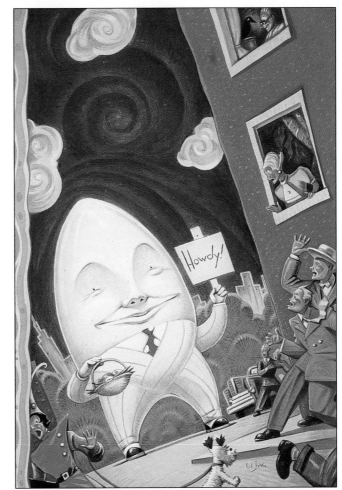

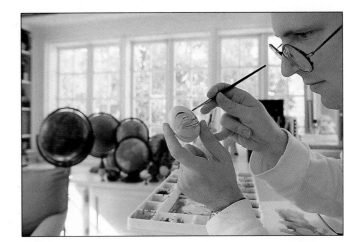

E A S T E R

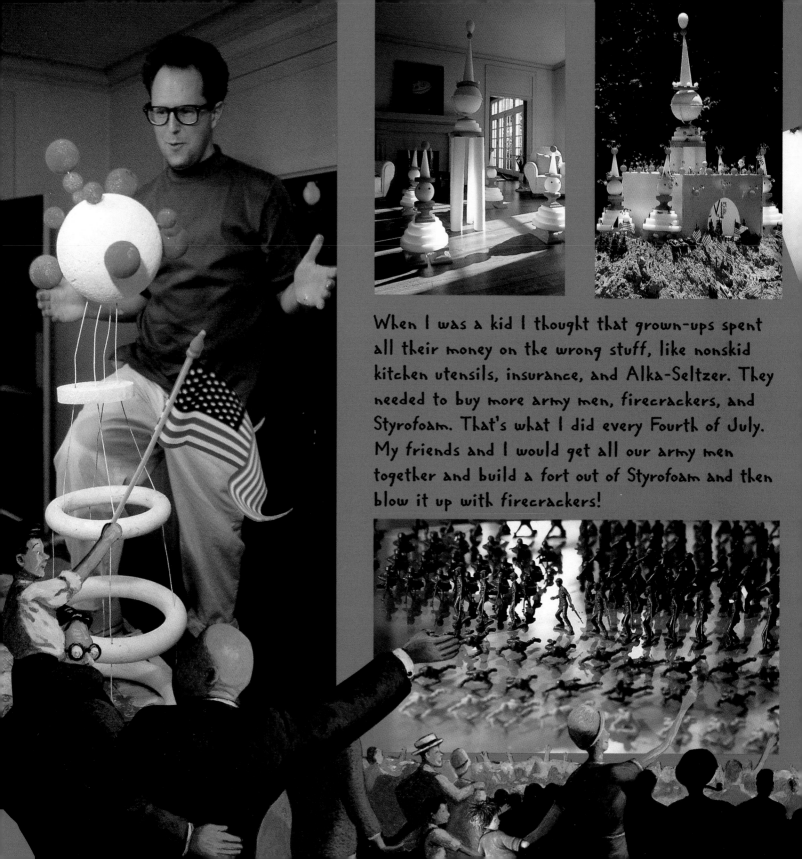

When I was a kid I thought that grown-ups spent all their money on the wrong stuff, like nonskid kitchen utensils, insurance, and Alka-Seltzer. They needed to buy more army men, firecrackers, and Styrofoam. That's what I did every Fourth of July. My friends and I would get all our army men together and build a fort out of Styrofoam and then blow it up with firecrackers!

When I grew up I kept doing the great Fourth of July blowup, first with my nephews, and now my own kids and my friends' kids.

It starts with a cookout with hot dogs and hamburgers. We spend the rest of the day building the fort and setting up the thousands of army men and toys. Everything is red, white, and blue, and there are flags aplenty.

Then, as I drive a remote-control car covered with missiles toward the fort, we put on our safety goggles and shout *One! Two! Three!* Everyone throws their smoke bombs. Then all the firecracker explosives go off. It's really *really* loud. One year we blew up over 25,000 firecrackers. Kids, moms and dads, sisters, brothers, cousins, uncles, aunts, grandmoms, granddads, neighbors—everybody has a blast.

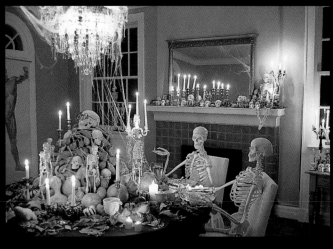

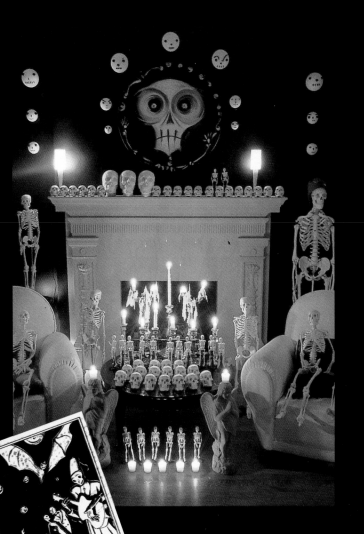

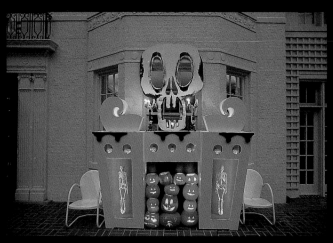

Halloween is maybe my favorite holiday. I take the whole month of October off and decorate the house. Every year, my next-door neighbors and I build some really spooky stuff—we've made 20-foot skeletons and a 30-foot spider. I've got over 100 skeletons in my closets, so we haul those all out, and paint the living-room walls with Halloween murals.

The Saturday before Halloween we have a huge party. Everybody comes dressed in costumes. One time some friends came dressed as people from one of my books. It's pretty weird to eat hors d'oeuvres with someone you made up in a book!

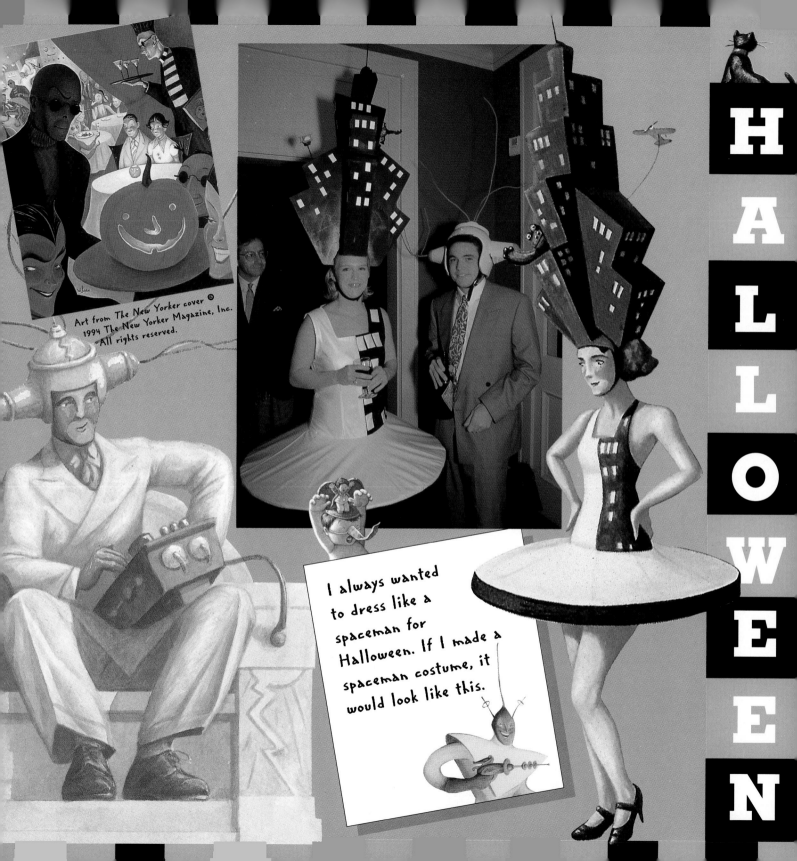

I always wanted to dress like a spaceman for Halloween. If I made a spaceman costume, it would look like this.

HALLOWEEN

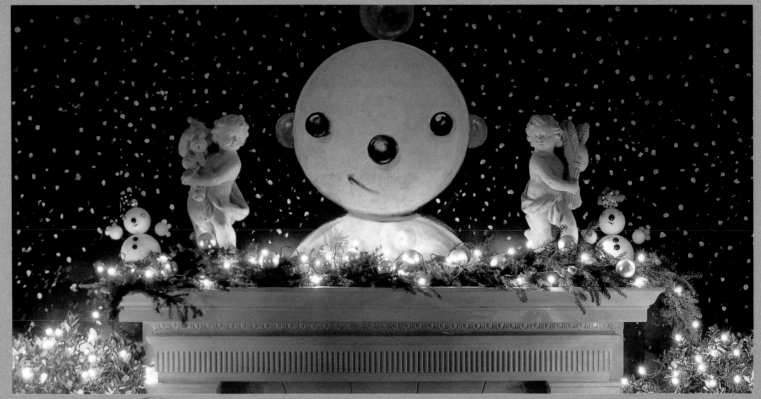

 At Christmas, I paint snowflakes on the living-room walls, covering up the black paint and ghouls left over from Halloween. And we have lots of trees; there's one for every bedroom and five in the living room, so it looks like a Christmas tree forest. Though we live in the South, where it's kind of hot, we try to have a cool Yule.

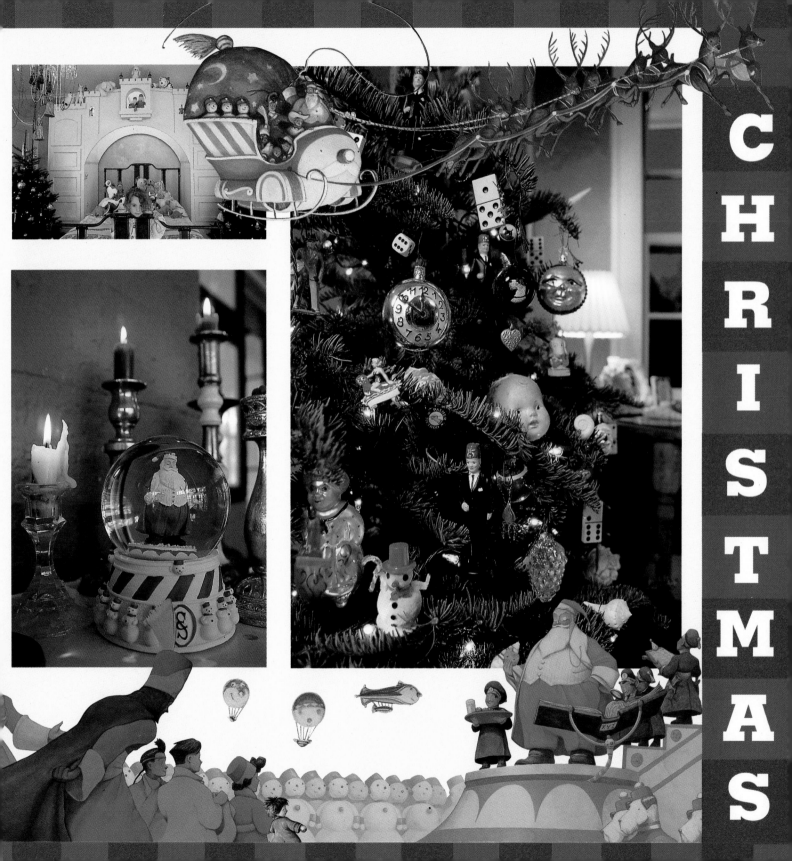

CHRISTMAS

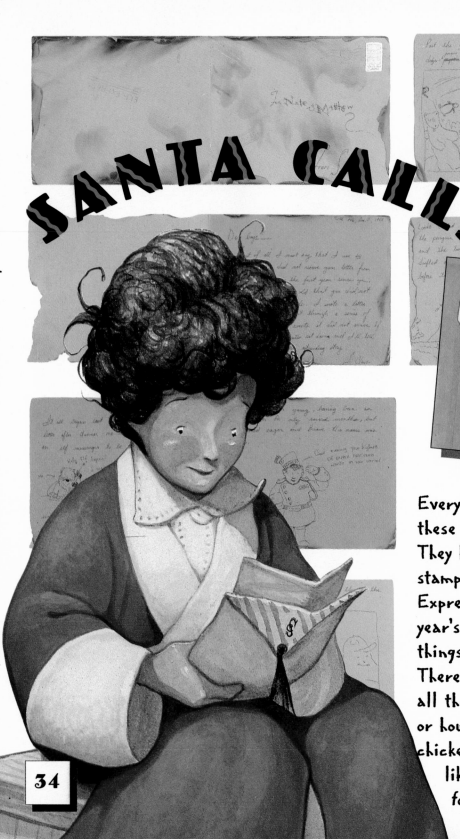

SANTA CALLS

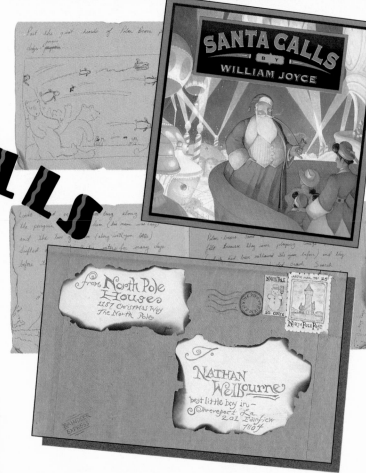

Every Christmas Eve my nephews received these elaborate letters from Santa Claus. They had their own special envelopes and stamps postmarked "North Pole Post" or "Elf Express." The letters told about the previous year's adventures at the North Pole and how things were going for Santa and his pals. There were stories about how it was so cold all the elves froze, Santa's trip to the moon, or how the elves chase snow cows and ice chickens, and how Santa's pet polar bear liked elf juggling. Every year we looked forward to Santa's letters.

But one year, no letter arrived. The next Christmas, an extra-fat letter came. It turned out that Santa had given last year's letter to Londo, a novice Elf Express messenger, who zipped off in his turbo-sky-scooter to deliver it. Londo flew fast and true, but he ran into a herd of polar bears playing dodge-penguin and was whacked in the head by a stray penguin. His sky-scooter spun out of control, and he and the penguin were thrown onto an iceberg, where they drifted in the Arctic Sea for so long that Santa and his elves gave them up for lost. The elves could do nothing but weep, and no toys were made. Christmas was in danger! Then, a miracle happened! Three days before Christmas, an iceberg washed ashore right near Santa's Ice Palace, and who do you think was on it? Londo and the penguin were safe and sound. And with nothing else to do they had made millions of toys—good elves always traveled with their emergency toy-making packs. Christmas was saved, and Londo received the Medal of the Mighty Elf, the elf world's highest honor.

Dear Nathan,

How are you my very good boy? I was checking my book the other day and I noticed what a good boy you've been this year. And it is my custom to send letters to my best boys and girls, so here you are— a letter from Santa!

I've sent along some pictures of myself and some of the elves and our house here at the North Pole, so now you know what we look like.

We've been working so hard to get all the toys ready for all the little boys and girls and we've still so much to do before Christmas!

Well, Nathan, my best little boy, I must be going now. I just wanted to let you know I was thinking about you and how good you've been. Tell your mommy and daddy Hello and pet Brandy for me. I'll write again next year.

Merry Christmas,

Santa

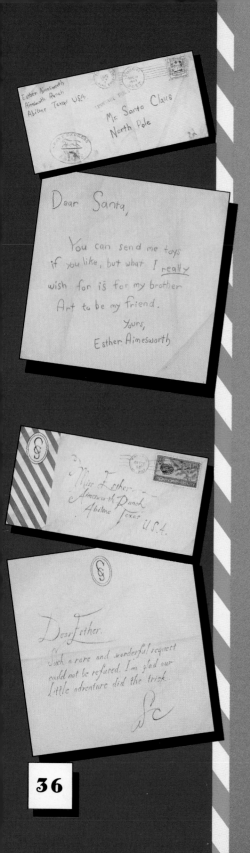

Envelope (top):
Esther Aimesworth
Aimesworth Ranch
Abilene Texas U.S.A.

Mr. Santa Claus
North Pole

Letter:
Dear Santa,

You can send me toys
if you like, but what I really
wish for is for my brother
Art to be my friend.

Yours,
Esther Aimesworth

Envelope:
Miss Esther
Aimesworth Ranch
Abilene Texas U.S.A.

Letter:
Dear Esther,

Such a rare and wonderful request
could not be refused. I'm glad our
little adventure did the trick.

S.C.

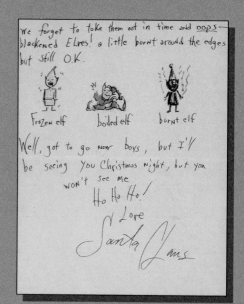

Dear Nate and Matthew,

Another year, another Christmas!

How are my two best boys this year!
My Records show that you've been
extra specially good so I'll be sure to
remember you both on Christmas Day—Toys Galore!

We're running a little late this year
because its been so Cold that the elves keep
freezing solid! Wanga Tanga (my best polar bear)
and I spend half our time thawing out the
elves by boiling them in hot water, but you know when
you boil elves they get all soft and mushy, like
spagetti. So then we have to hang them out
to dry in the ovens. This works well but sometimes
we forget to take them out in time and oops—
blackened Elves! a little burnt around the edges
but still O.K.

Frozen elf boiled elf burnt elf

Well, got to go now boys, but I'll
be seeing you Christmas night, but you
won't see me
Ho Ho Ho!
Love
Santa Claus

The ice palace got buried under the snow.

WANGA TANGA BATTLES THE MOON "IT"

Me and The Elves Packing up the great Sack!

Off to the moon we go!

Look how nice this years Tree is!

The elves chase the snow cows the ice chickens and Me!

Wanga Tanga does his famous elf juggling Act!

Santa's letters to my nephews got
me thinking about what would
happen if Santa really was in
need of help. He might send a
mysterious summons to some
children, along with a flying
machine that would carry them to
the North Pole. That seemed like
the greatest adventure a kid could
ever have—going to Toyland and
meeting Santa. And that's how I
came up with the idea for Santa
Calls.

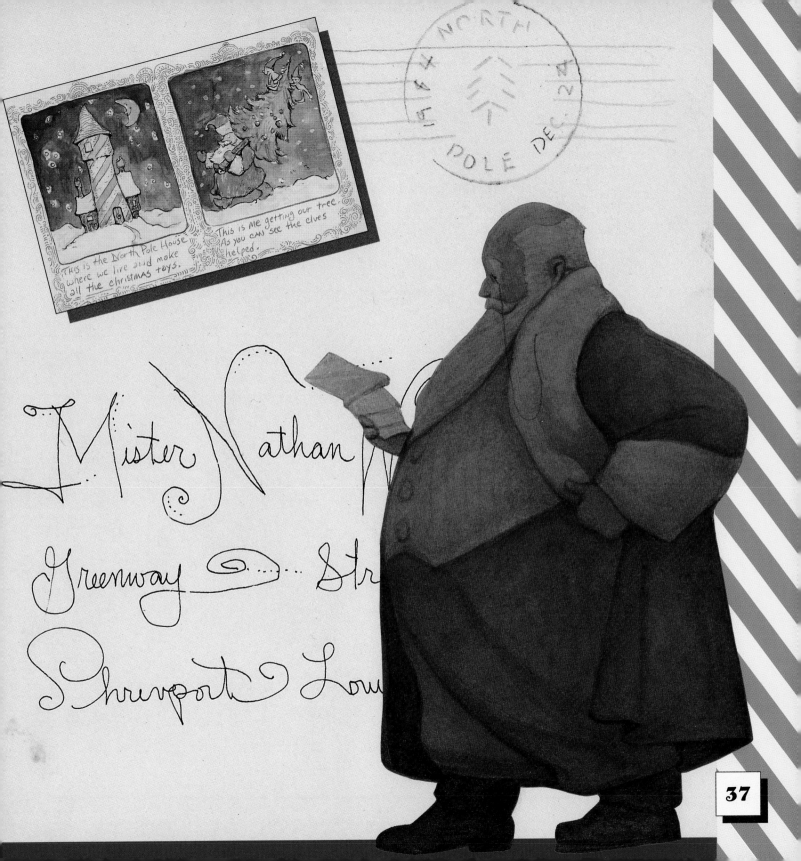

This is the North Pole House where we live and make all the christmas toys.

This is me getting our tree. As you can see the elves helped.

NORTH
POLE DEC. 24

Mister Nathan

Greenway 〇 Str

Shrivport Lou

37

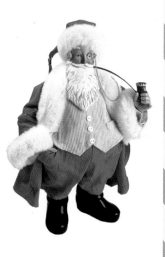

Sometimes the neatest, most unexpected things happen after you finish a book. Not long after *Santa Calls* was published, I got a call from the mayor of Abilene, Texas, and I thought, *Yeah, right*. Once he convinced me he was *really* the mayor, he told me that he had just come from one of the elementary schools, where the teacher had given him *Santa Calls* to read to the class. As he read the first page, he couldn't believe his eyes, for the first page of the book says that Art Atchinson Aimesworth "lived in Abilene, Texas. . . ."

I told him I'd never been to Abilene, and had chosen the name because it sounded cool. So I went to visit them. Abileneans are the nicest bunch of people. They're building a National Center for Children's Illustrated Literature—the first and only museum in the country solely dedicated to children's literature. They even built a twelve-foot-tall bronze sculpture based on *Santa Calls*!

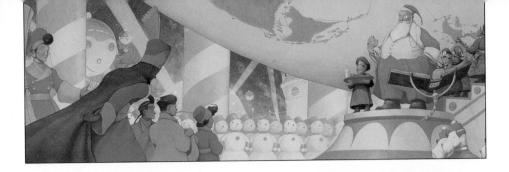

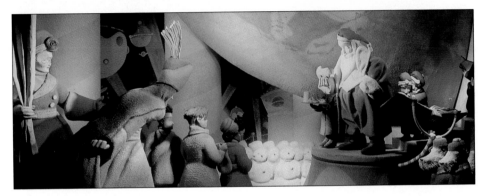

Saks Fifth Avenue, a really big department store in New York City that has the most amazing Christmas windows in the world, really liked *Santa Calls*. They made huge mechanical puppets out of scenes from my book. They also had me design a bunch of ornaments and gifts based on Santa— it was great. I felt like Santa himself—making toys.

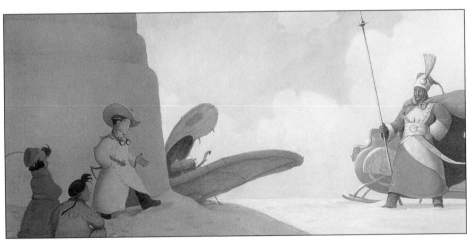

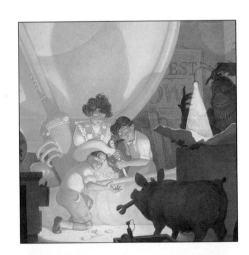

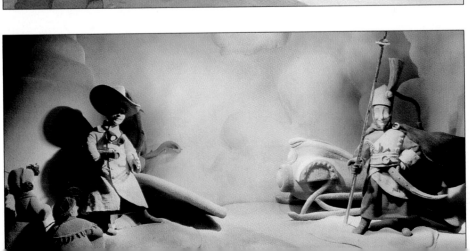

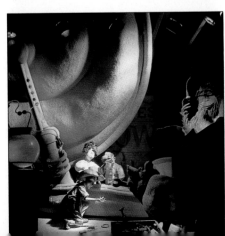

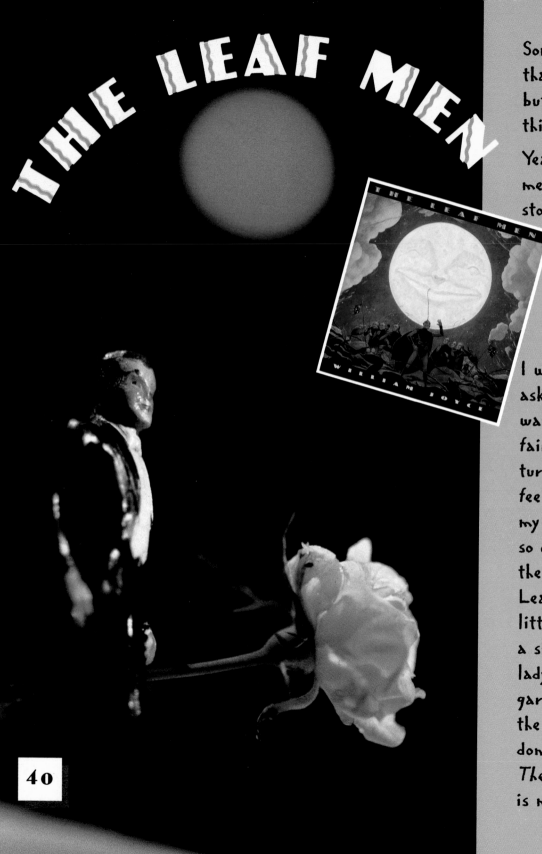

THE LEAF MEN

Sometimes I find something that I want to write about, but it takes me a while to think of just the right story.

Years ago I bought this little metal man at an antique toy store. I wanted to do a book about him, but I couldn't think of a good adventure for him to have. So I put him away on a shelf.

One day my daughter and I were in our garden, and she asked me to tell her a story. I wanted to tell a story about fairies and goblins and creatures of moonlight. And I was feeling kind of sad because my best friend was very sick, so out came this tale about the metal man, the magic Leaf Men, and some brave little bugs and how they save a sick old lady and her garden. Of all the books I've done so far, *The Leaf Men* is my favorite.

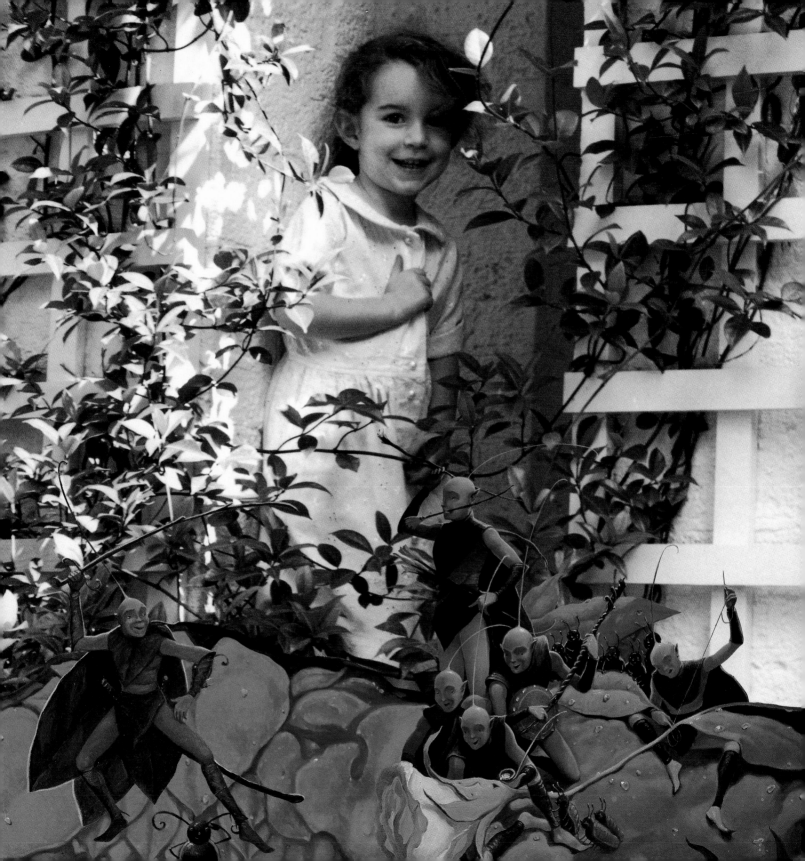

Buddy

As I was growing up, my favorite movie was *King Kong*. Almost all of my books have little references to Kong. *George Shrinks* and *Bently & egg* each have little King Kong dolls hidden in them. In *Shoes*, a picture of Kong is on the front page of a newspaper, and in *Wilbur Robinson*, Wilbur's sister is dressed as her favorite movie for her school prom. The movie? *King Kong*, of course! (If you go to the Halloween pages of this book, you'll see that she's wearing an Empire State Building hat with a little airplane and a little King Kong on top.)

A while back I was asked to write a movie about a zoo. When I was looking up books about zoos, I found the true story of a woman named Gertrude Lintz who raised all sorts of creatures in her house: chimpanzees, dogs, horses, squirrels, owls, tropical birds, rabbits, mice, fish, butterflies, leopards—you name it, she raised it. But her favorite animals were her gorillas. She had all their clothes tailor-made in New York City; she took them to the movies; she taught them how to eat at the table, play croquet, do light housework, and play musical instruments. They were even stars of the 1933 World's Fair. So here was this true story, about a lady and a gorilla, that happened in the same time period and in the same city as *King Kong*. I never thought I'd base a book on a real-life story, but this one was too much fun to pass up.

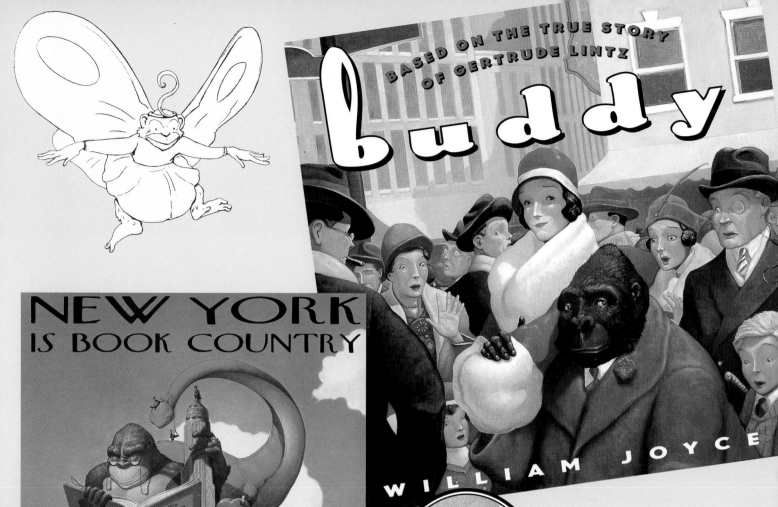

BASED ON THE TRUE STORY OF GERTRUDE LINTZ

buddy

WILLIAM JOYCE

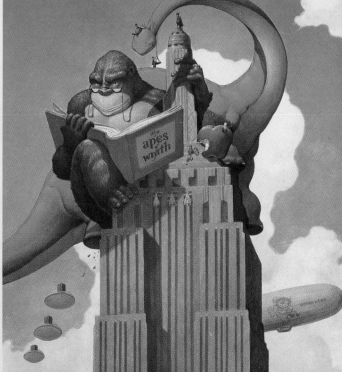

NEW YORK
IS BOOK COUNTRY

The apes of wrath

SEPTEMBER 15, 1991
FIFTH AVENUE · 48TH TO 57TH STREETS · 11AM ~ 5PM

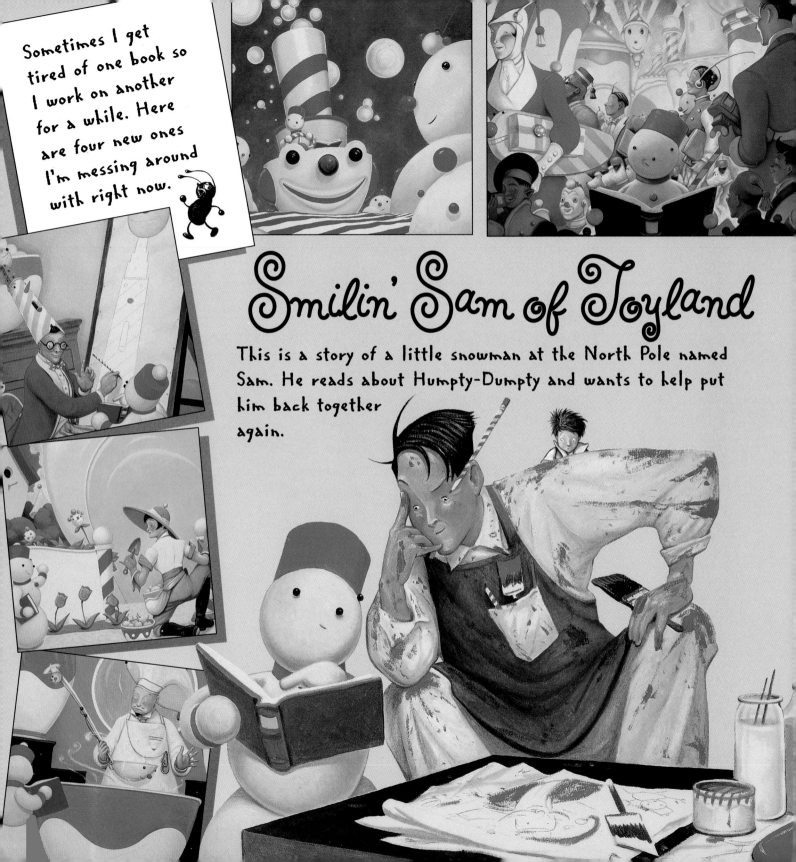

Sometimes I get tired of one book so I work on another for a while. Here are four new ones I'm messing around with right now.

Smilin' Sam of Toyland

This is a story of a little snowman at the North Pole named Sam. He reads about Humpty-Dumpty and wants to help put him back together again.

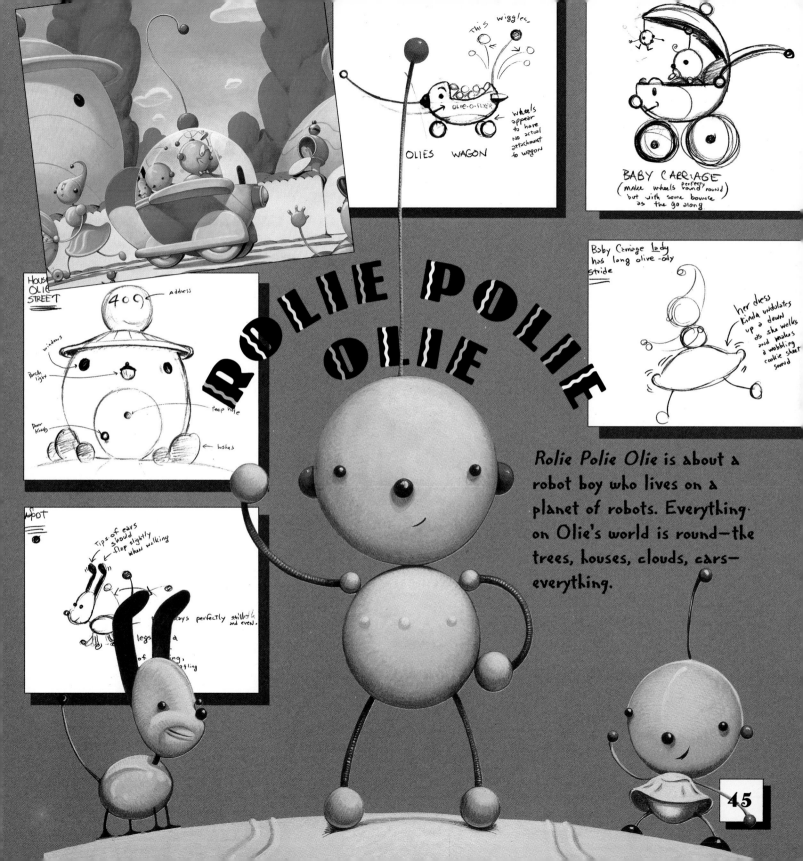

This wiggles.

OLIE-O-FLYER

Wheels appear to have no actual attachment to wagon

OLIES WAGON

BABY CARRIAGE
(make wheels perfectly round 'round) but with some bounce as the go along

HOUSE OLIE STREET

409 — address

windows

Porch light

Door knobs

Peep hole

— lashes

Baby Carriage lady has long olive-oily stride

her dress undulates kinda down up a down as she walks and makes a wobbling cookie sheet sound

SPOT

Tips of ears should flap slightly when walking

...rays perfectly and even.

legs a

ROLIE POLIE OLIE

Rolie Polie Olie is about a robot boy who lives on a planet of robots. Everything on Olie's world is round—the trees, houses, clouds, cars—everything.

45

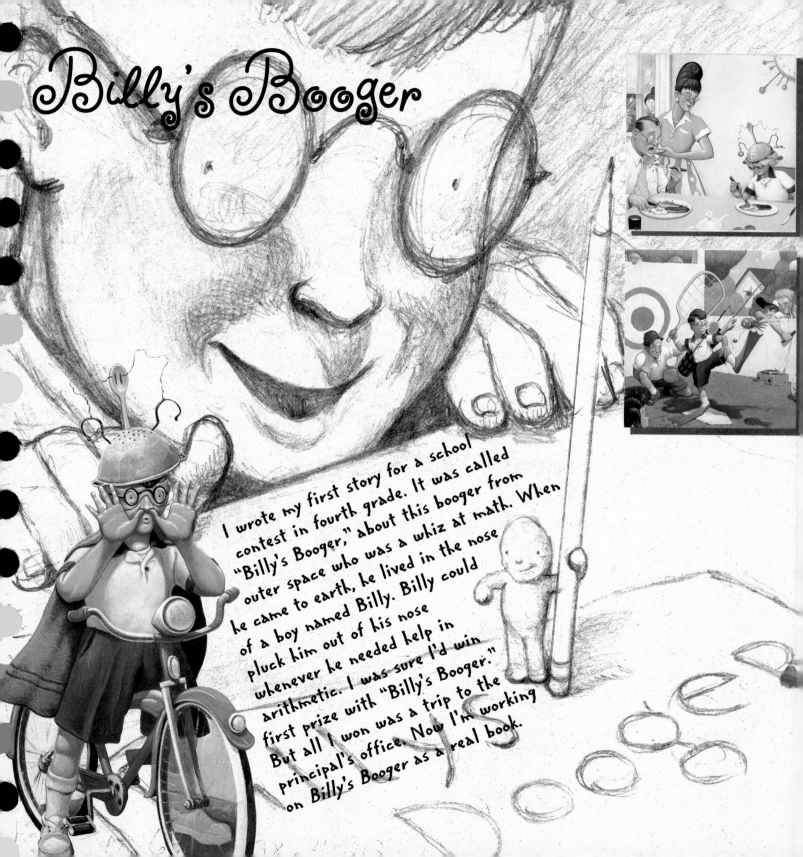

Billy's Booger

I wrote my first story for a school contest in fourth grade. It was called "Billy's Booger," about this booger from outer space who was a whiz at math. When he came to earth, he lived in the nose of a boy named Billy. Billy could pluck him out of his nose whenever he needed help in arithmetic. I was sure I'd win first prize with "Billy's Booger." But all I won was a trip to the principal's office. Now I'm working on Billy's Booger as a real book.

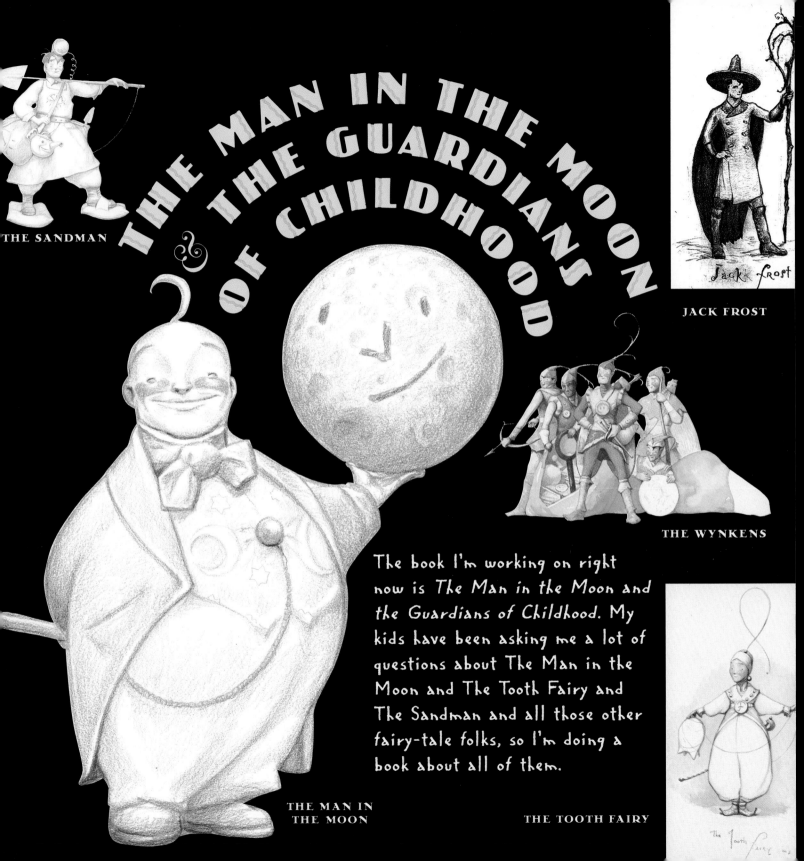

THE MAN IN THE MOON & THE GUARDIANS OF CHILDHOOD

THE SANDMAN

JACK FROST

THE WYNKENS

THE MAN IN THE MOON

THE TOOTH FAIRY

The book I'm working on right now is *The Man in the Moon and the Guardians of Childhood.* My kids have been asking me a lot of questions about The Man in the Moon and The Tooth Fairy and The Sandman and all those other fairy-tale folks, so I'm doing a book about all of them.

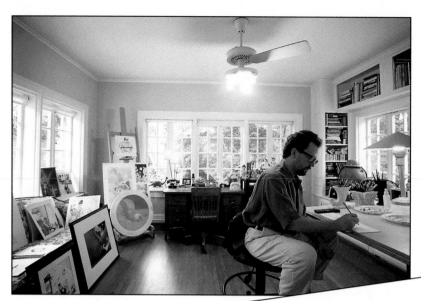

Did you find all the hidden Georges? There are 10 teeny tiny Georges starting on page 18...

So that's sort of the story of how I do what I do. I still draw all the time, just like when I was a kid. I sit at my desk, and I never know where the page will take me, or who I'll meet, or what adventure we may go on.

THE END